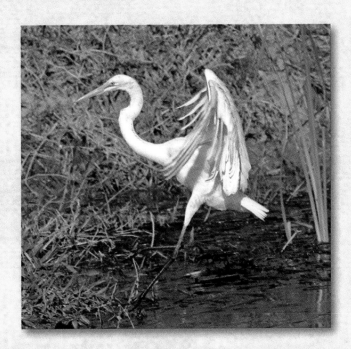

Great Egret

This book is a photographic journey of the
Birds We See in the estuaries, arroyos and
seashores of Los Cabos and the East Cape
region of Baja. It contains more than 185
original photographs of some of the many
birds that live here or stop over during annual
migrations.

www.BirdsWeSee.com

This book is dedicated to my wife, Debbie.
January 14, 2005 our lives changed forever. Pretty much out of the blue and after a 9 hour surgery that was supposed to be about 1, Debbie was diagnosed with stage 4 ovarian cancer. She was given a 5% chance of living 6 months. So after working 24/7 from the time we were married we decided to take time from our real estate business and go see the things and places we had always wanted to see. Always with cameras in hand we traveled to places like The Galapagos Islands, Costa Rica, The Arctic Circle, Africa and The Amazon Jungle. We spend a lot of time taking pictures of birds in the desert arroyos and the estuaries near our second home on Baja Sur's East Cape. Our friends can't seem to believe the variety of the birds we see here. It's now 6 years later and we're still shooting birds here, with our cameras, of course. C.E.Llewellyn

on the cover:
The male
Xantus's
Hummingbird

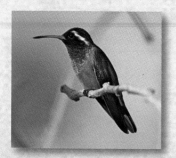

female

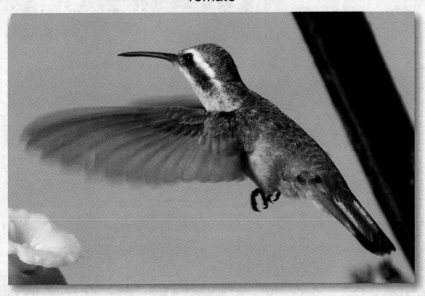

Xantus's Hummingbird

Named after Hungarian zoologist John Xantus de
Vesey, Xantus's Hummingbirds are endemic to Baja
but may wander as far north as British Columbia.
These may be our favorite hummingbirds we see
at the feeder or out in the garden here in Los
Barriles. 3-4"

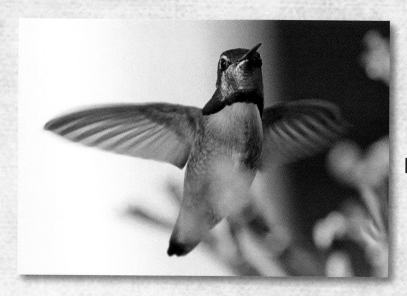

The brilliant male **Costa's Hummingbird.**

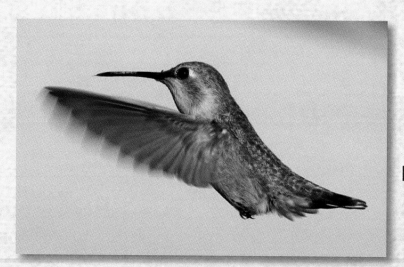

And a beautiful female **Costa's Hummingbird.**

male

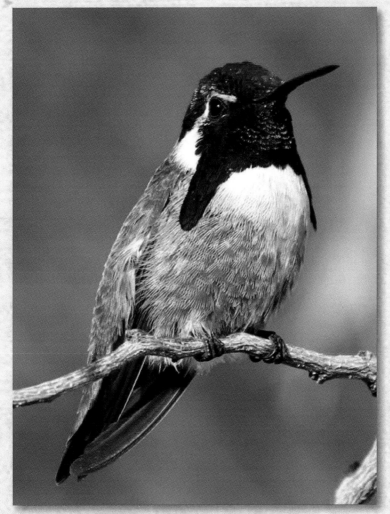

Costa's Hummingbird

The male **Costa's Hummingbird** has a deep violet crown and gorget while in breeding plumage. Like most hummingbirds, Costa's feed on large amounts of tiny insects as well as nectar from colorful flowers. 3"

female

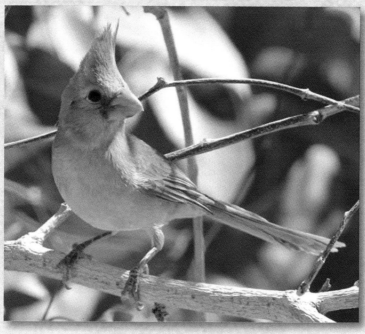

Northern Cardinal

Considered non-migratory birds. Few
Northern Cardinals survive to be adults
due to heavy nest predation especially
by the common Raven and, in Baja
Sur, the Coachwhip snake. 8-9"

Pictured below is a female **Cardinal**
and a female **Pyrrhuloxia**.

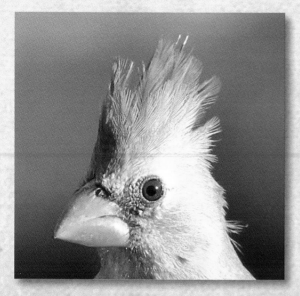

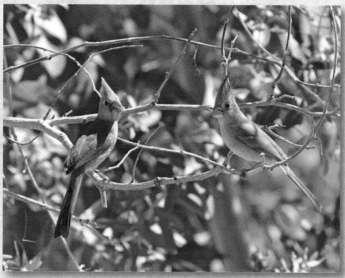

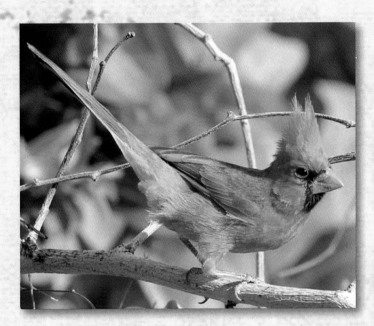

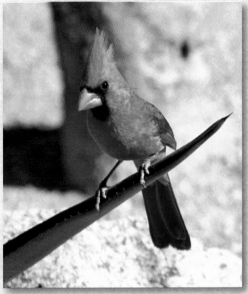

Northern Cardinals are the
state bird for seven U.S. states,
more than any other bird. They
feed primarily on the ground
consuming seeds and insects and
are known to live at least 15 years
in the wild.

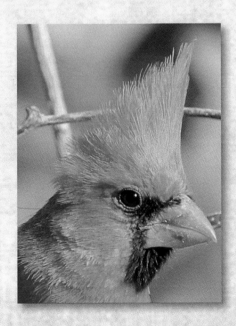

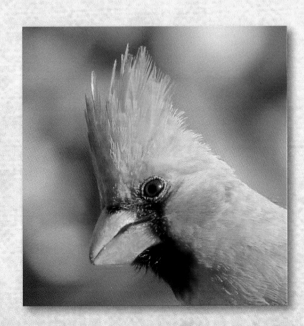

female

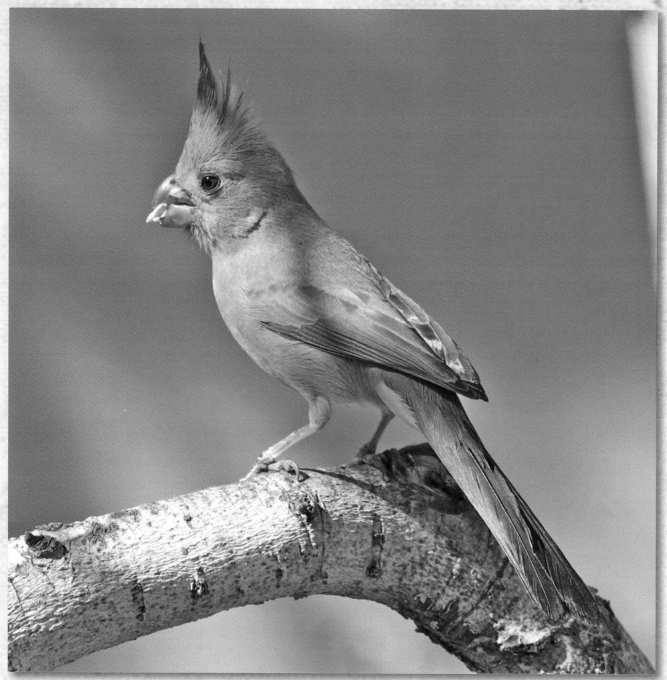

Pyrrhuloxia

These birds feed on seeds and large
amounts of crop destroying insects. 8-9"

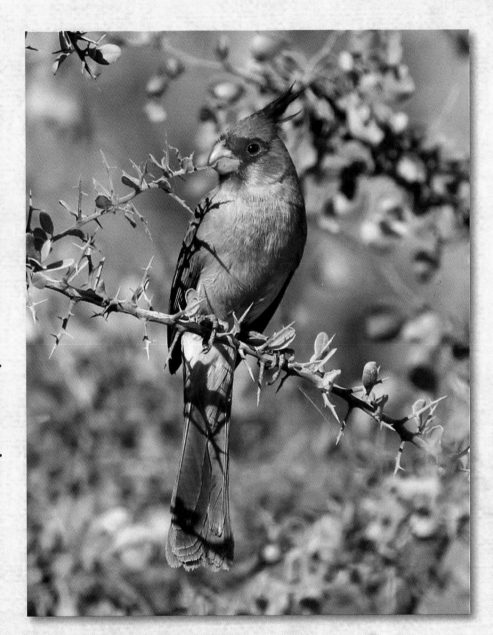

These cardinal-like finches are very alert. When we approach a pair of Pyrrhuloxias near their nest they will fly to a high post and sound a loud alarm. Sounds something like Cheer-cheer-cheer, sweet-sweet-sweet. Pyrrhuloxias have strong, parrot like bills used for opening seed shells.

Pyrrhuloxia

Also known as the Gray Cardinal

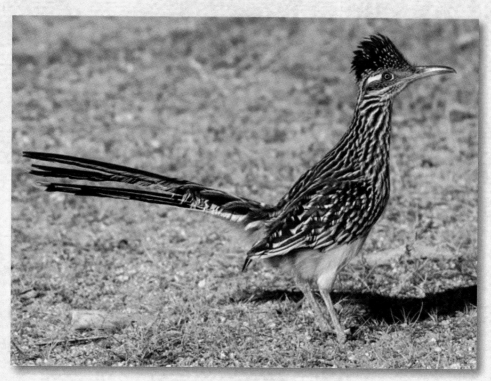

Greater Roadrunner

When we see these ground dwelling cuckoos from the road they are usually running away from us, hence the name. Greater Roadrunner's diet includes lizards, insects, snakes, rodents and even small birds. 23"

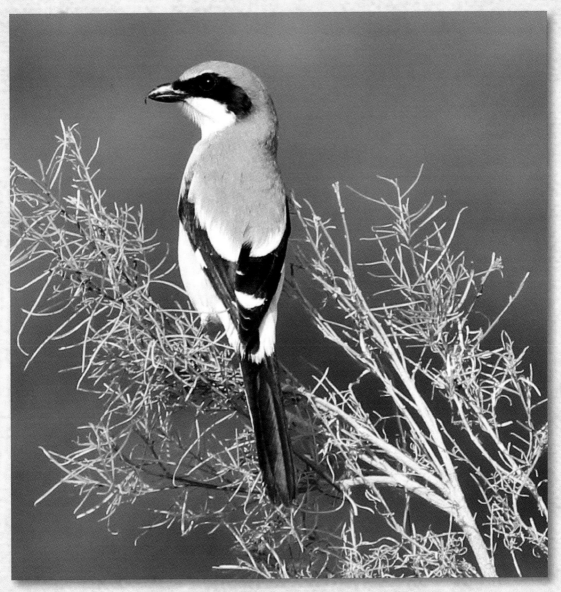

Loggerhead Shrike

Also known as the butcherbird. These birds
have a habit of impaling insects or lizards
on cactus spines or even barbed wire to
feed on later. 9"

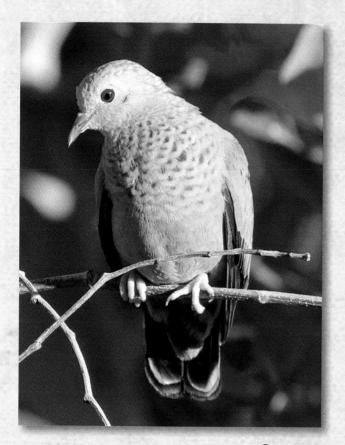 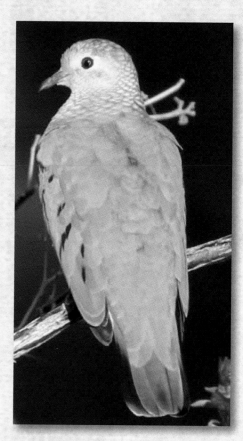

Common Ground Doves

These are sparrow sized doves that
fly fast, beating their short wings
almost like those of a quail.

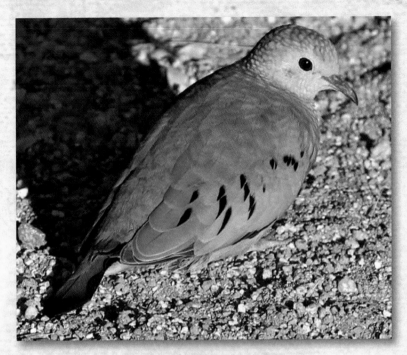

Common Ground Dove

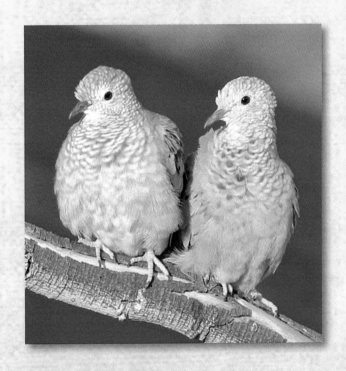

These birds feed on seeds they find on the ground. During courtship, the male pursues the female nuisance like, bobbing his head in rhythm with it's monotonous cooing. 6-7"

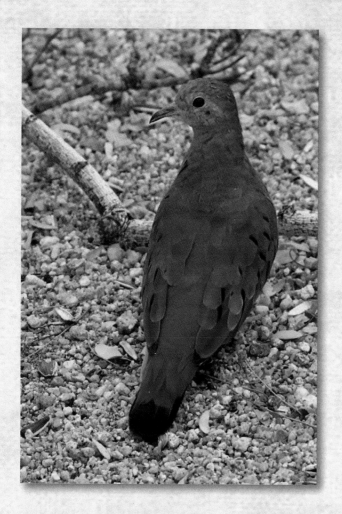

Ruddy Ground Doves are widespread in Latin America. When we see these birds in Baja Sur they are often in the company of the similar sized Common Ground Dove. 7"

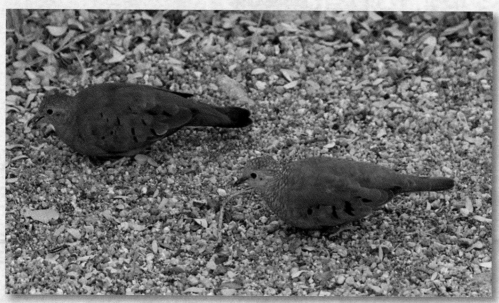

Ruddy Dove Common Ground Dove

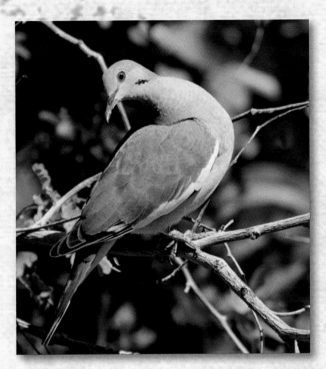 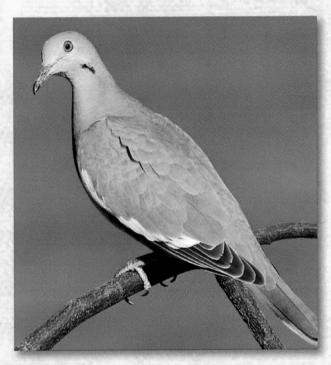

White Winged Doves

These doves are sometimes called pigeons because of their large size. They will flock in large numbers and can be agricultural pests. Being fast fliers and good to eat, these birds are considered by many a sporting game bird. 12"

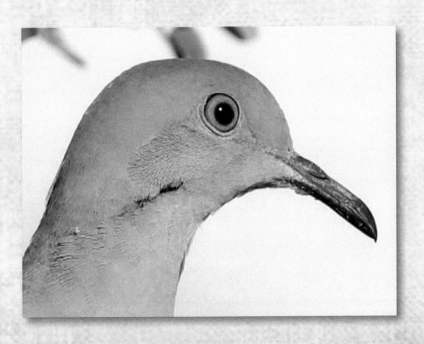

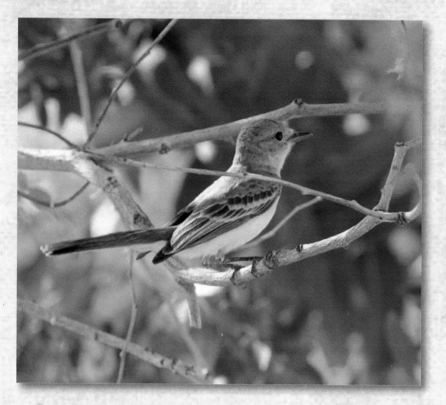

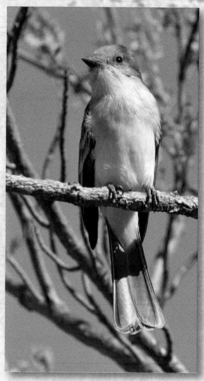

**Ash Throated
Flycatcher**

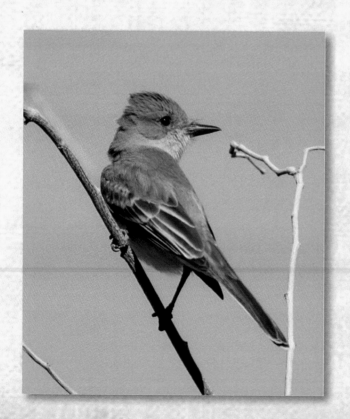

We see these birds
hovering over a spot
in the sand to clear an
area of debris. They will
then lay in the hot sun
with wings spread out
like a snow angel in the
sand to rid themselves
of parasites.
These flycatchers have
a call something like
that of a softly blown
coach's whistle. 8"

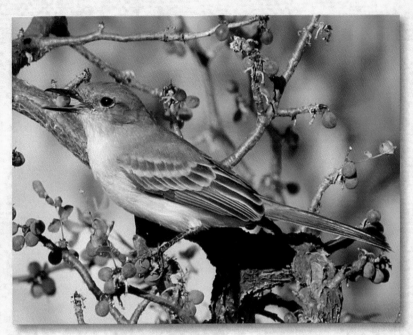

Ash Throated Flycatchers

These birds feed on insects and the
ripe berries of the Elephant Tree.

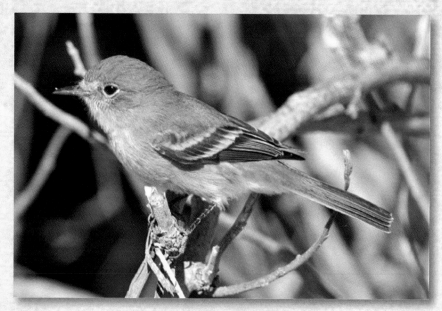

Gray Flycatcher

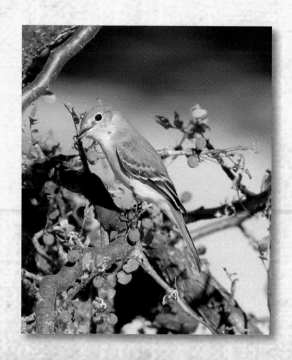

These are fairly small flycatchers that are very active in the spring chasing flying insects as well as foraging for berries.

Gray Flycatcher's habit of quickly raising their tail and then slowly lowering it(just the opposite of most flycatchers) helps distinguish this bird from other flycatchers in Baja Sur. 6"

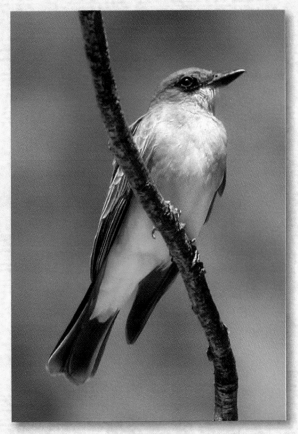

Cassin's Kingbird

When we see these flycatchers they are usually in pursuit of flying insects. Most flycatchers dart from a perch to snap up insects from the air but **Cassin's Kingbirds** will chase their prey for 40 to 60 feet before giving up pursuit if they have to. 9"

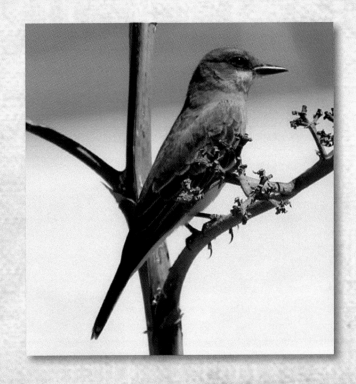

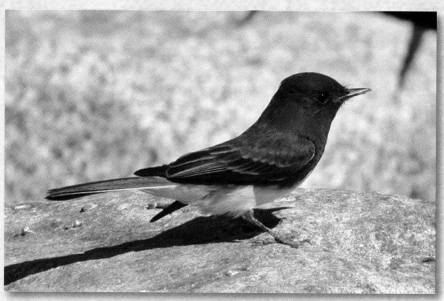

Black Phoebe

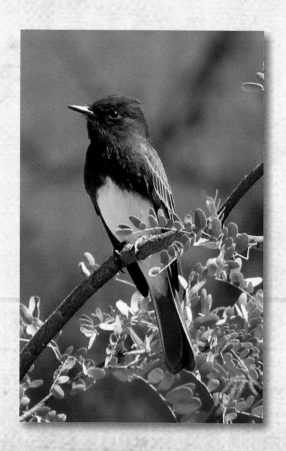

These are medium sized flycatchers. **Black Phoebes** are almost always found near fresh water where they chase insects. We also see them snatch little minnows from the surface of the water. 7"

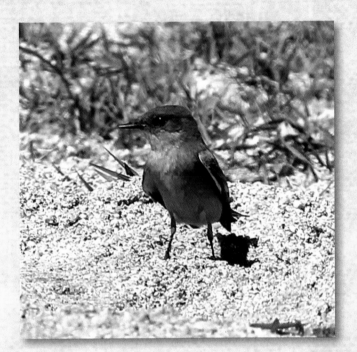 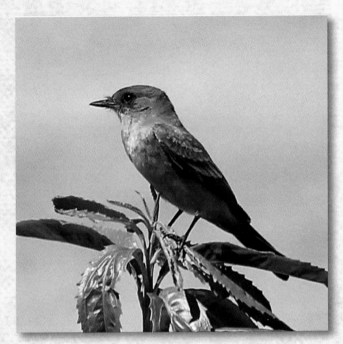

Say's Phoebe

Named after the American naturalist Thomas Say, the **Say's Phoebe** is highly migratory. We see these birds in Baja in the winter and Oregon in the summertime. 7-8"

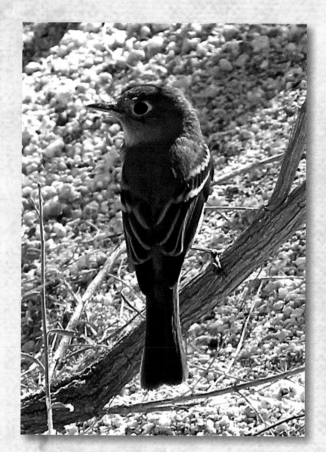 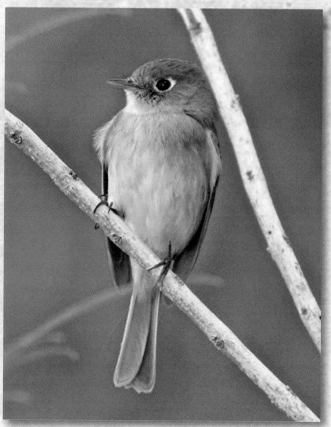

Pacific-slope Flycatcher

We usually see these
flycatchers while they are
hunting near fresh water ponds
and marshes.
These birds will dart from
their perch to catch a flying
insect often to return to the
same place time and time
again. 6"

female

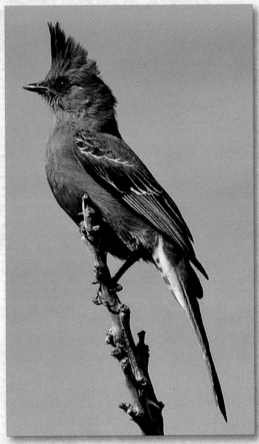

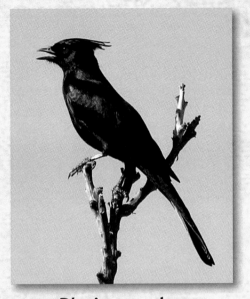

Phainopeplas
are the only silky
flycatchers in
North America.
The male birds are
shiny black except
for the white wing
patches that can
only be seen while
the birds are in
flight.

Phainopeplas

male

These birds feed
chiefly on insects
and mistletoe
berries,
consuming as
many as 1000
berries per day.
8"

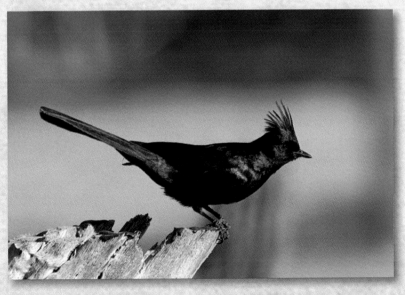

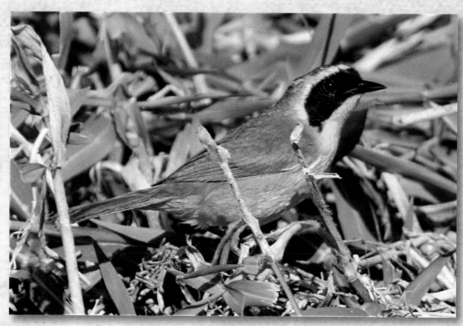

Belding's Yellowthroat

Closley related to the Common
Yellowthroat, the Belding's Yellowthroat
is endemic to Baja. One of the few
remaining places to see these warblers
is at the San Jose del Cabo estuary.
They briefly appear on the brush tops
then quickly disapear deep inside to
forage for insects. 5-6"

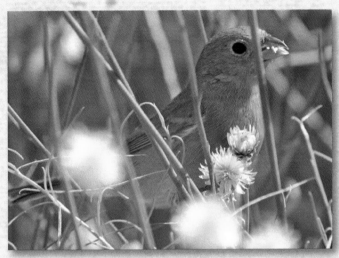

Varied Bunting

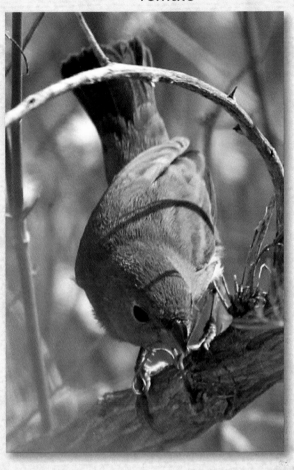

We find find these birds
deep inside a thorny bush
where they are foraging for
seeds and insects. 5"

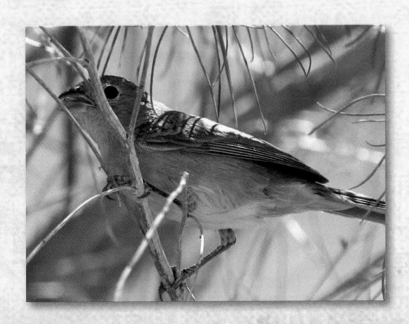

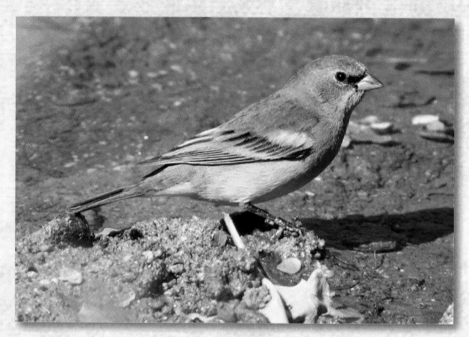

Lazuli Bunting

A beautiful, shy bird named after a semi
precious stone mined in Afghanistan that
has been prized since antiquity for its
intense blue color. 6"

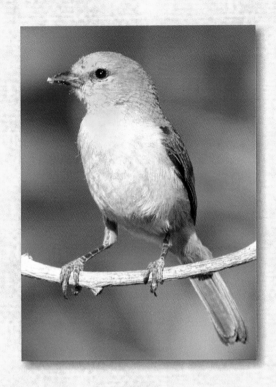

The tiny **Verdins** build their spherical nests using thousands of twigs. They feed on insects, seeds and nectar. 4"

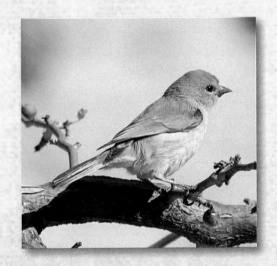

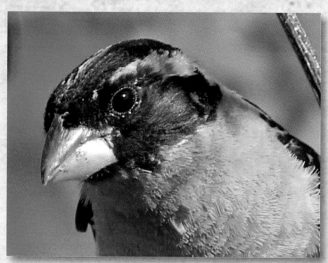

Audult male

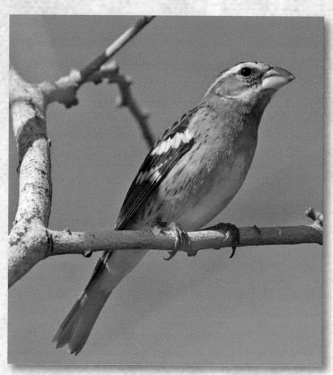

Black-headed Grosbeak

First year

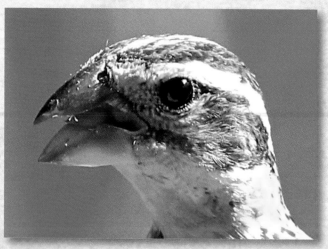

One of the few birds that
can safely eat the poisonous
monarch butterfly. These birds
also consume large amounts
of seeds which they open with
their powerful bills.

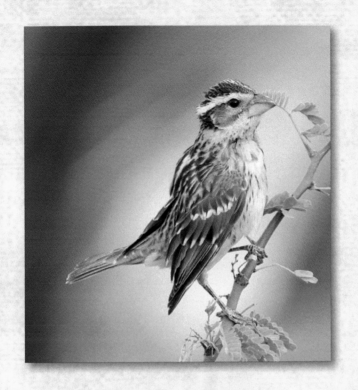

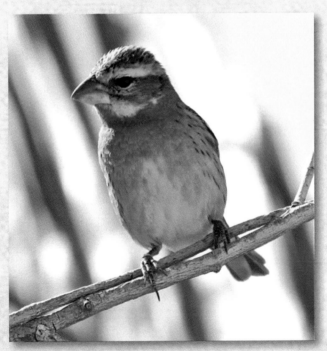

The song of the **Black-headed Grosbeak** is similar to that of a robin only softer and sweeter. 8"

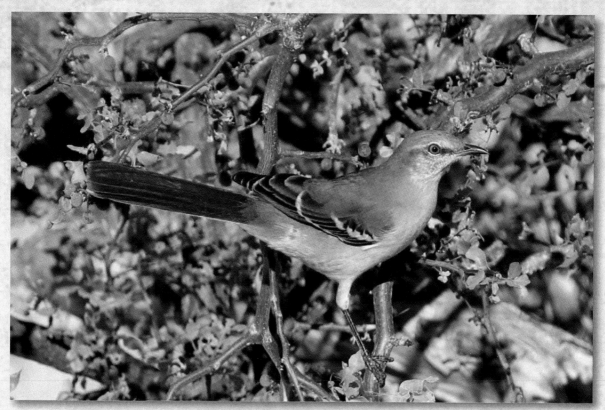

Northern Mockingbird

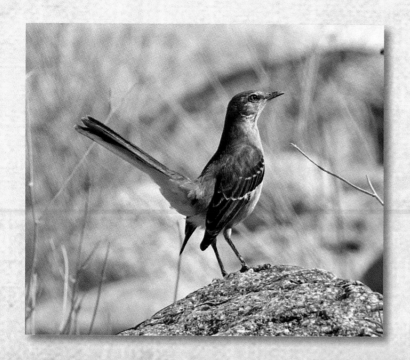

These birds imitate the songs of other birds and aggressively defend their territory from intruders. They feed primarily on insects and fruit. 10"

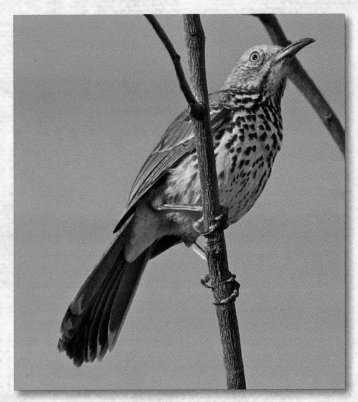

Gray Thrasher

A Baja endemic, **Gray Thrashers** spend much of their time on the ground searching for insects and seeds. They will perch in the same spot for hours singing songs with the sweetest, liquid, musical qualities. 9"

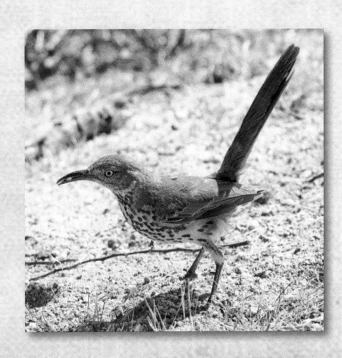

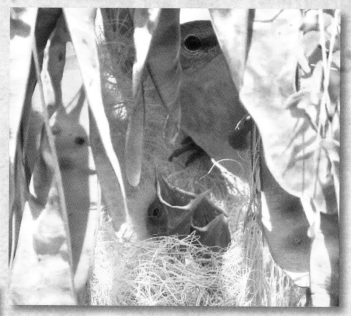

Babies in the nest.

female

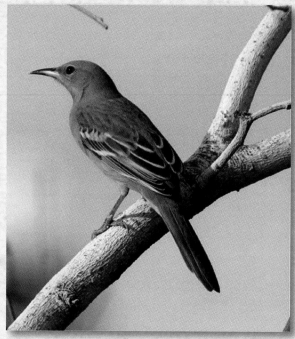

Hooded Oriole

Both parents share
equally in the nesting
responsibilities. 8"

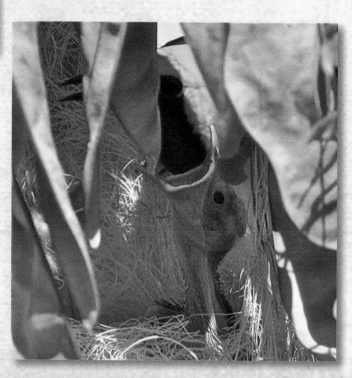

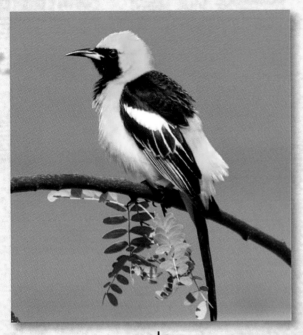
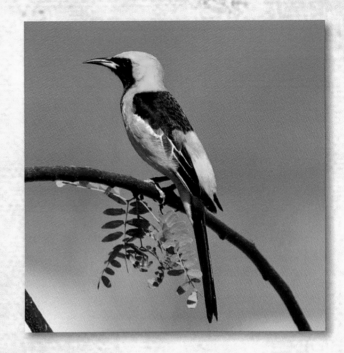

male

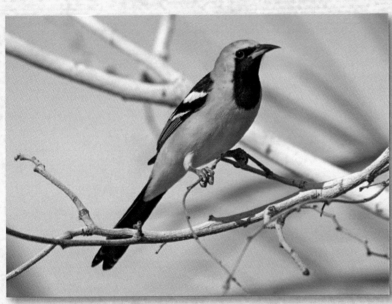

Hooded Orioles are wonderful songsters. Listening to some of the chatter they do we are sure they must be talking to each other. They also make this "Stevey Wonder at the piano" sort of gesture that is very amusing.

female

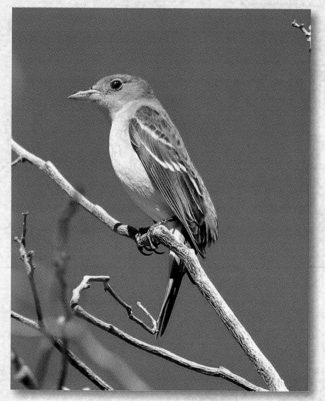

Scott's Oriole

When we see female **Scott's Orioles** they always seems to be using their tails to steady themselves on a perch. 9"

Tuli Pan trees are a favorite source of nectar and insects for many birds including the **Scott's Oriole.**

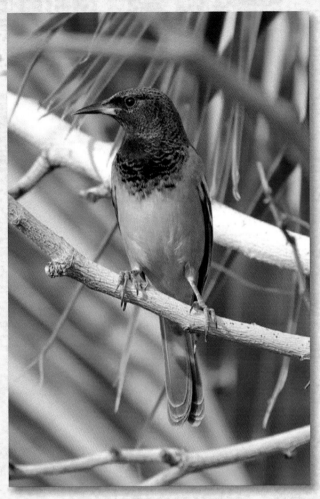

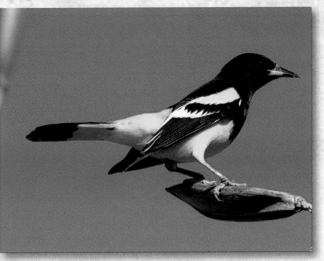

Scott's Oriole

Juvenile **Scott's Oriole**

male

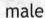

Not only do they feed on insects, fruit and seeds, **Scott's Orioles** are also frequent visitors at the hummingbird feeders. One of the finest songsters and first birds to sing in the morning throughout most of the summer.

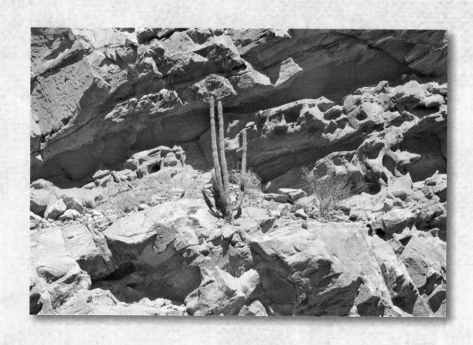

Life clings to steep rocky cliffs like these which line the desert arroyos of Baja California Sur, creating a perfect habitat where we see **Canyon, Rock, and Bewick's Wrens.**

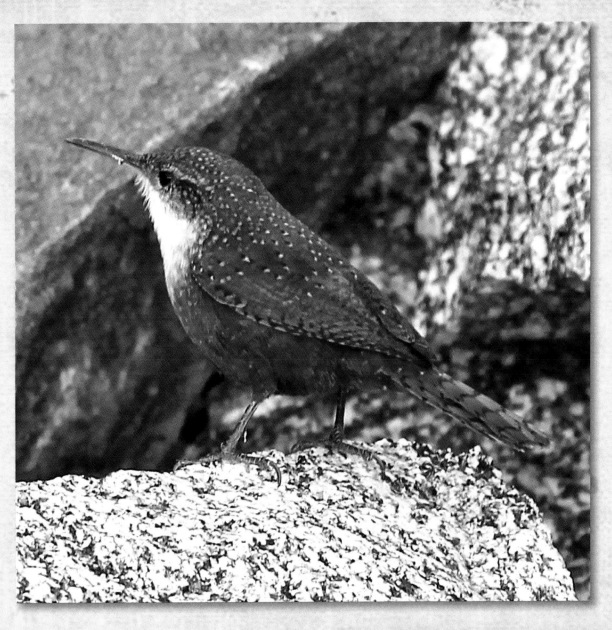

Canyon Wrens have flat heads and long bills that enables them to reach deep into crevices to find prey, primarily insects. 5-6"

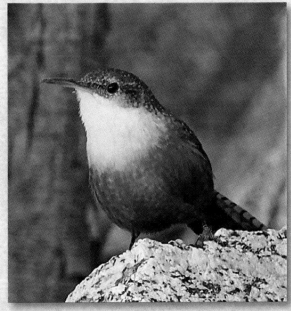

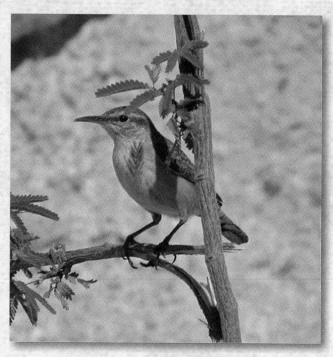

Bewick's Wren

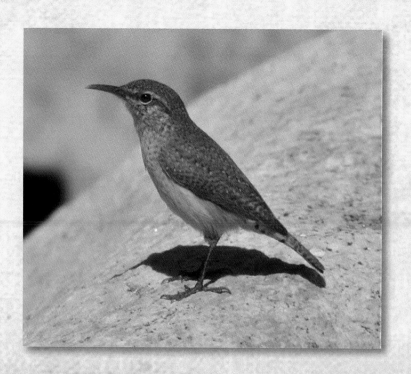

Named for Thomas Bewick, the English naturalist. **Bewick's Wrens** blend in with their surroundings making them very difficult for us and predators to see. These wrens feed mostly on insects. 6"

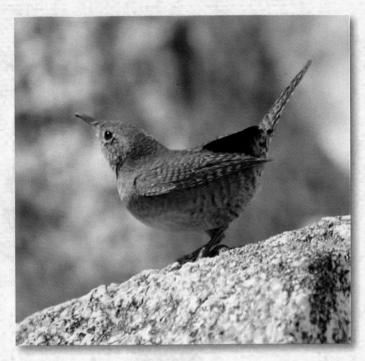

Rock Wren

Rock Wrens sing many different
musical songs but the voice we hear most
is chewee,chewee,chewee, echoing in
the canyons. The males have the
interesting habit of building a pathway of
pebbles in front of their nest. 5-6"

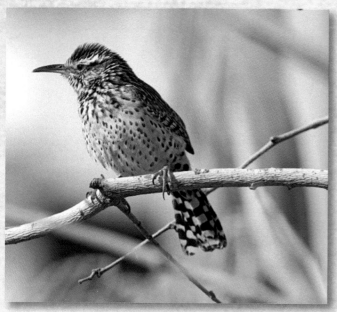

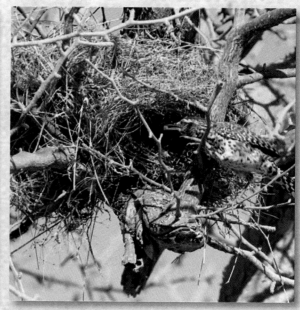

Cactus Wren nest

While foraging on the ground, **Cactus Wrens**, (the rascals of the desert), are constantly prodding holes and tipping over debris to discover what may be hiding there. If we leave the front door open a pair of **Cactus Wrens** will invite themselves in to investigate. They build a large bulky nest in Cholla cactus or thorny bushes for the spiny protection they provide. 8-9"

Cholla Cactus

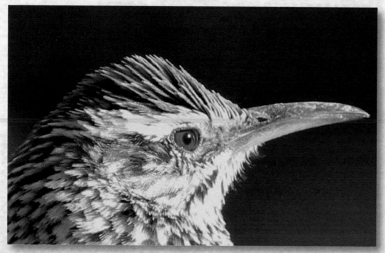

male

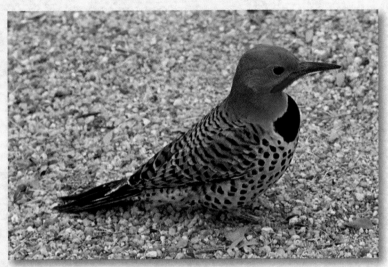

Gilded Flicker

female

These woodpeckers make their nest in a hole in a saguaro cactus or a hollow cavity in a tree. They primarily feed on insects they find on the ground such as ants, termites and grubs while using their head like a hydrolic hammer. 12-13"

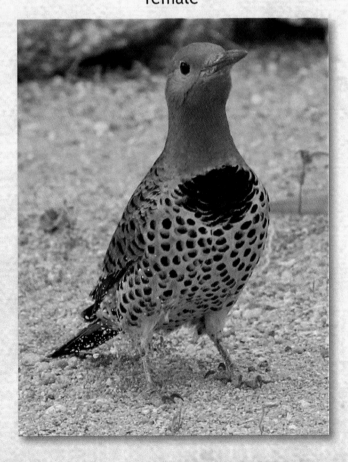

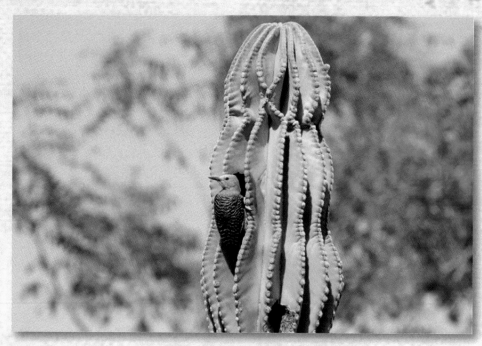

Gila Woodpecker at the nest

Spiny-tailed Iguanas compete
with **Gila Woodpeckers** for
shelter and nesting holes in
Cardon cactus.

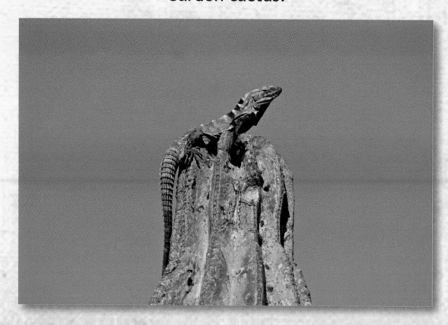

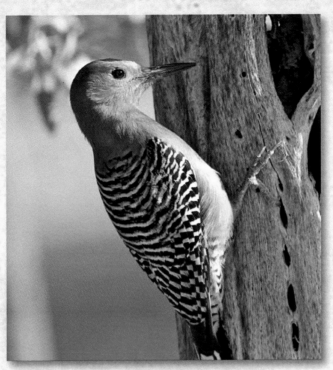

Gila Woodpecker

Like most woodpeckers, **Gila Woodpeckers** are hole nesters. These birds feed on insects, seeds and nectar from cactus flowers and other desert plants. 9"

male

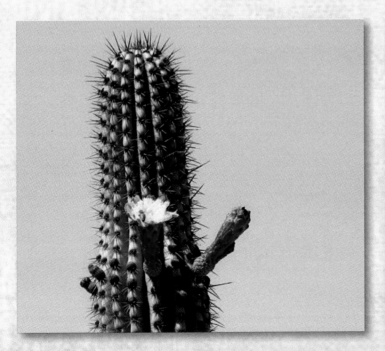

male

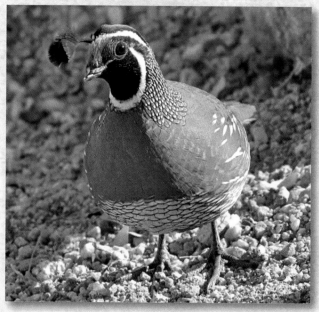

California Quail

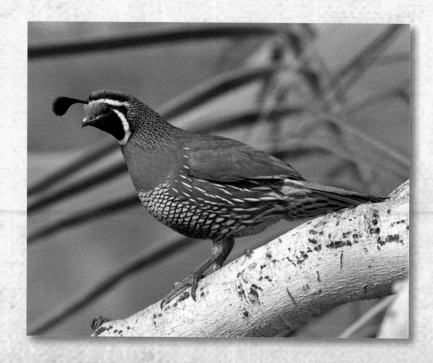

The top notch of these very fast running, mostly ground dwelling birds looks like one feather but is actually a cluster of 5 or 6 plumes. 10"

female or hen

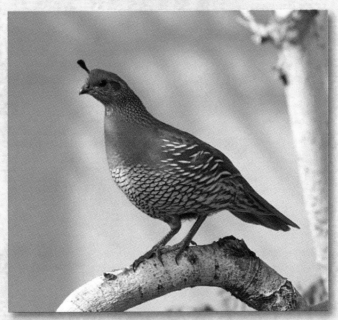

California Quail.

We usually hear these birds long before
they are seen. They have a noisy
"ka-**kahhh**" call. When a 'covey' of
California Quail is foraging for seeds
and insects there is usually a male bird
perched high nearby keeping a keen
lookout for predators.

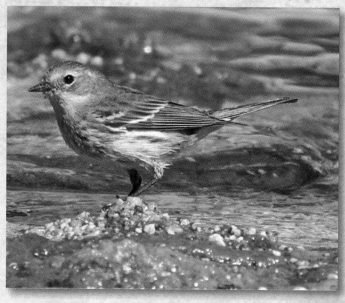

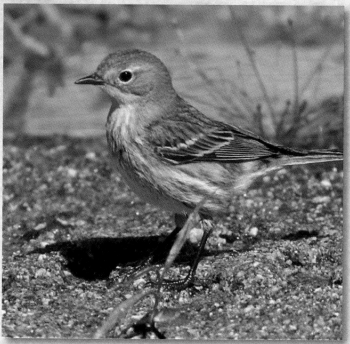

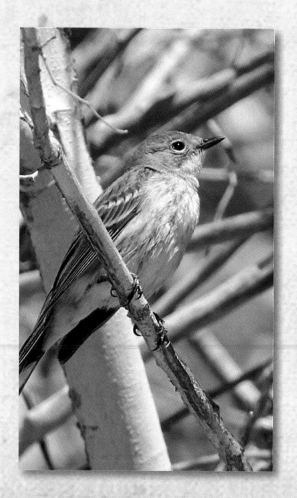

Yellow-rumped Warbler

One of the most common warblers in North America. **Yellow-rumped Warblers** feed primarily on or near the ground searching for seeds and insects. Birds in the flock constantly chirp to help keep the "bouquet" (a flock of warblers) together. 5-6"

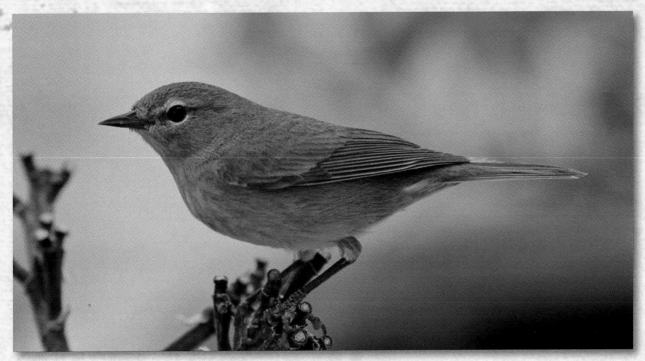

Orange-crowned Warbler

Some **Orange-crowned Warblers** are yellow, especially on the Pacific side of Baja California.

These birds nest on the ground and only display their orange crown during courtship or when alarmed. 5"

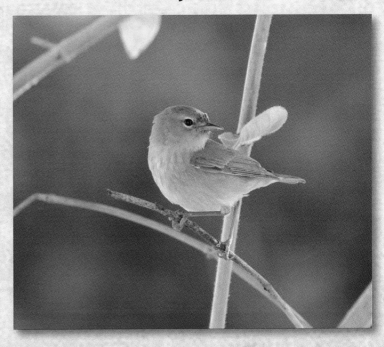

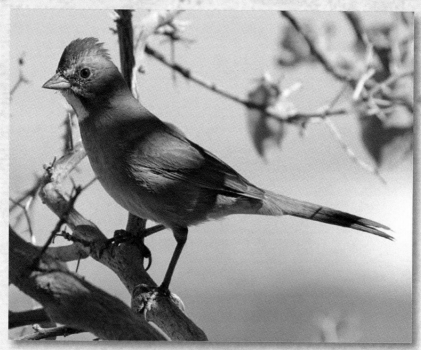

We hear these birds scratching around on the ground searching under bushes for insects and seeds long before we see them. 7"

Green-tailed Towhee

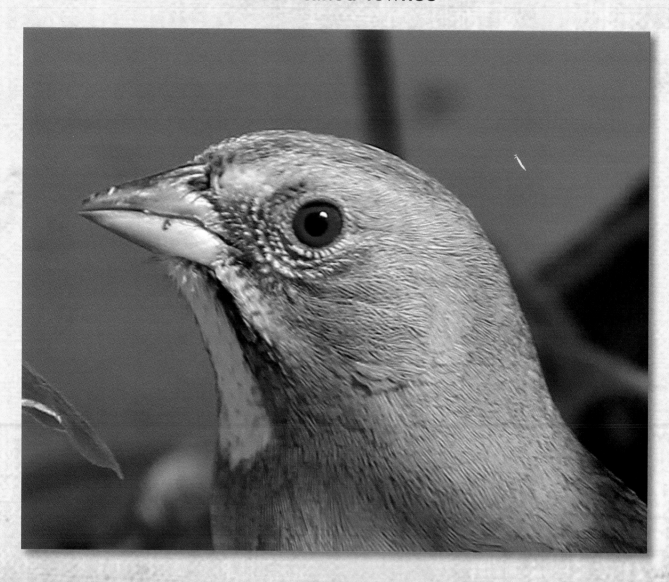

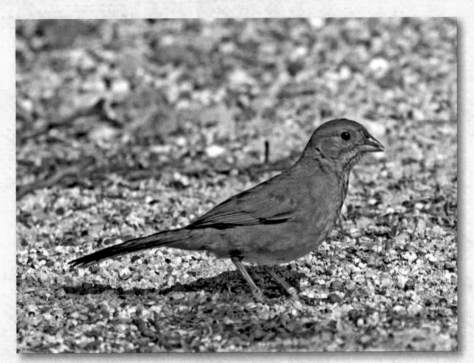

California Towhee

These towhees are very territorial
and sometimes we wake up to
find them fighting with their own
reflection in a window. 9"

first year

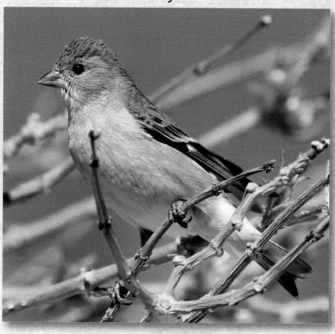

Lesser Goldfinch

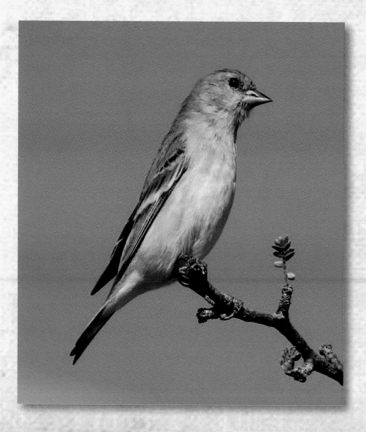

Usually when we see one
Lesser Goldfinch, many more
will be arriving any minute.
Their unmistakable voice, like
that of a kitten's mew, is always
a pleasure to our ears.

male

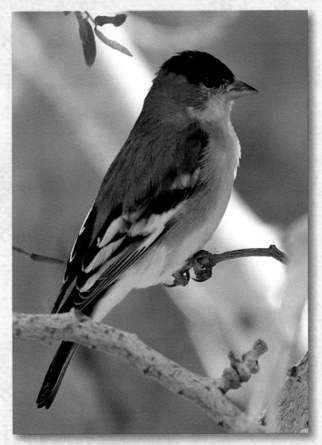

Lesser Goldfinch

These birds feed mainly on
seeds but will also eat small
insects. 4-5"

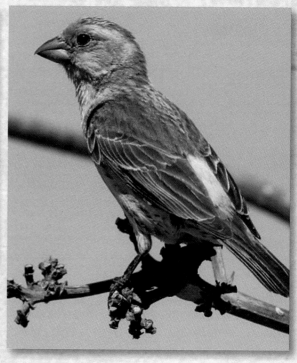

Formally a familiar resident throughout the western U.S. caged birds were released in the east in the 1940s and they are now widespread and common in eastern North America as well. The male's coloration varies from reds to yellows to oranges depending on their diets.

male

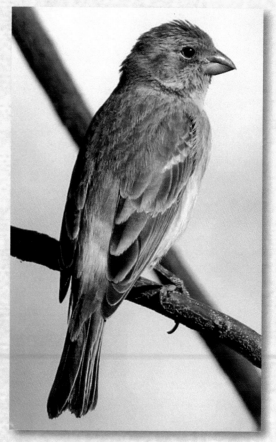

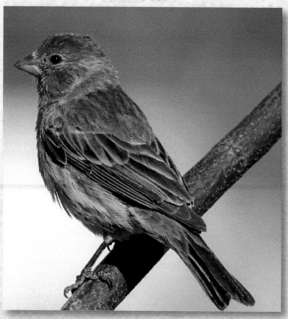

House Finch

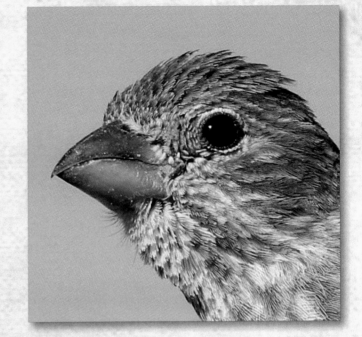

female

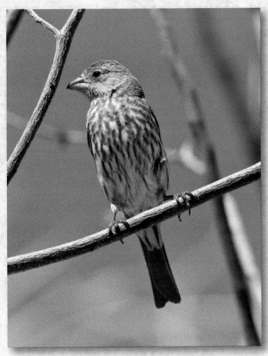

House Finch

These plentiful birds feed primarily on insects and seeds. **House Finches** are sometimes considered agricultural pests when they flock on farmer's fields. 6"

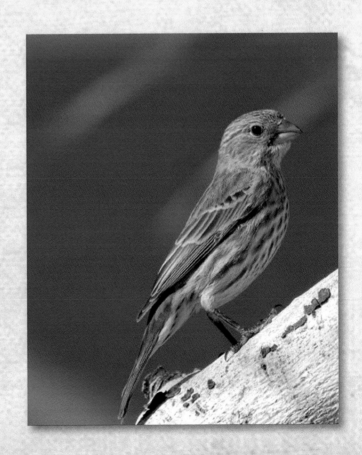

The geology and climate of Baja
California, Sur is profound and
diverse. In the Buenos Aires
arroyo near Los Barriles, Wild Fig
trees appear to grow right out of
the rock to provide shelter, food
and shade for birds and other
animals.

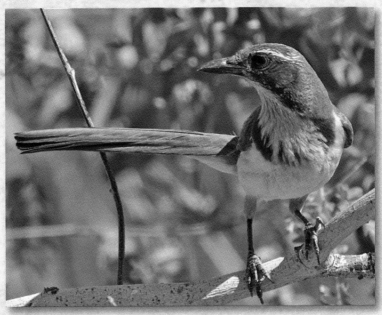

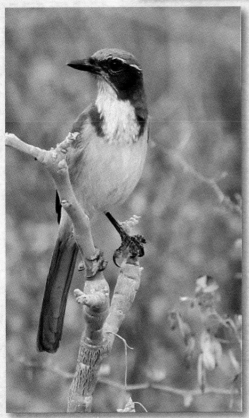

Western Scrub Jays feed on insects, fruit, seeds and also rob the nests of other birds.

Western Scrub Jays feed on such large amounts of seeds that many, especially acorns, are lost in transit or excreted to fall and germinate far from the mother plant. 11"

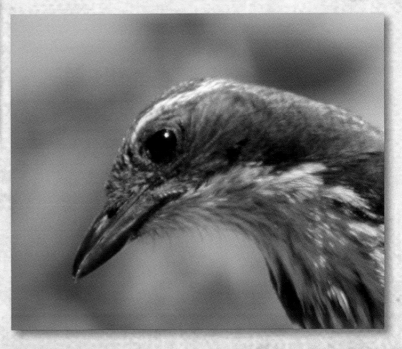

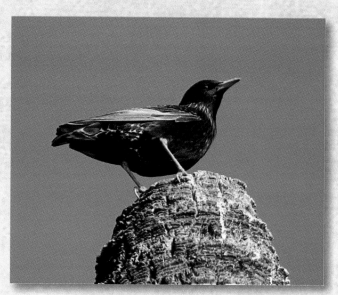

European Starling

babies

European Starlings were introduced to New York from Europe in the 1890s. Their dark greens and blue plumage splashed with bright stars are beautiful to see. They soon spread across the continent and have recently colonized Baja Sur. These birds aggressively compete with native birds for holes in trees and cardons for nesting. 8-9"

Blue-gray Gnatcatcher

These birds sing a thin musical
warble that has a nasal quality. They
constantly flick their white-edged
tail from side to side to scare up
insects and spiders while foraging for
prey. 4-5"

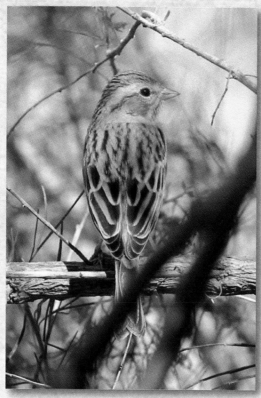

Brewer's Sparrow

There are two distinct breeding
populations, one in Yukon's
Rocky Mountains and the other
in sage brush deserts of western
United States. 5"

Note the leg bands on this **White-Crowned Sparrow** at right. These birds are studied more than any other sparrow in the United States due to their large numbers and variety of sub-species and behaviors.

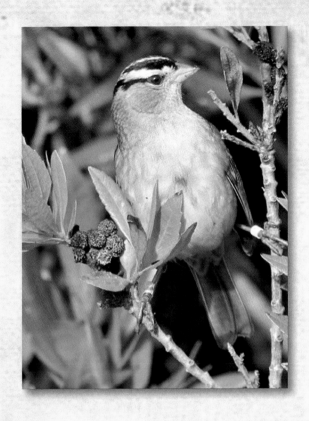

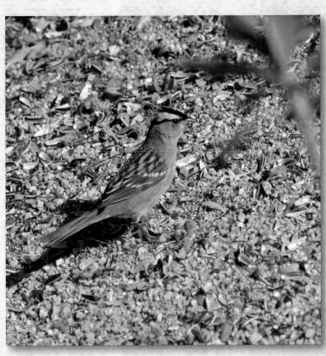

At right, an immature **White Crowned Sparrow**. At 7" it is a large sparrow and very wide-spread. This bird's brown head stripes will turn black as it ages leaving a white crown.

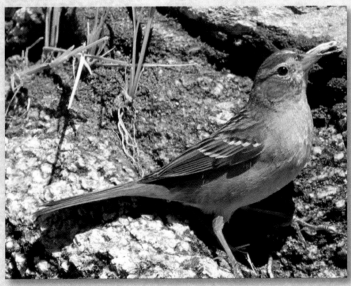

male

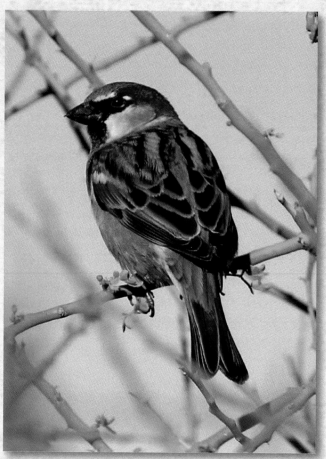

House Sparrow

House Sparrows are native to Britain and other European countries. They now live on all continents except Antarctica. These birds eat seeds, fruit and insects. 6"

We see these birds when we go to town more than in the countryside. They always seem to be foraging around outdoor restaurants searching for crumbs.

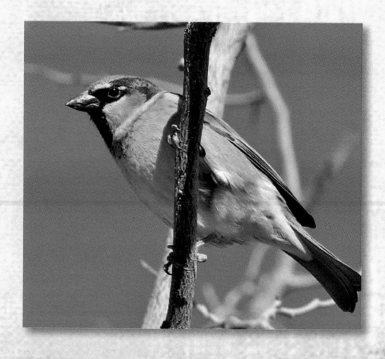

female

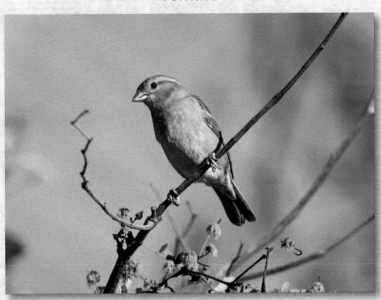

House Sparrow

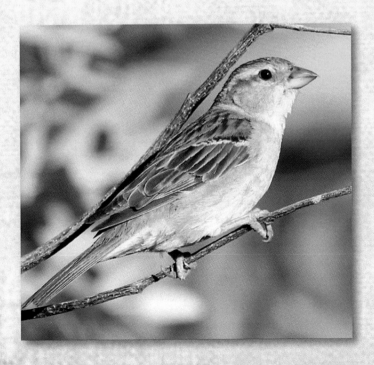

Sometimes called the English Sparrow, the **House Sparrow** is extremely adaptable to a wide range of habitats. They seem to thrive in cold, damp climates at high altitudes as well as dry desert lowlands.

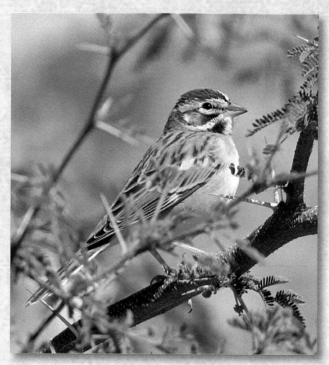

Lark Sparrow

We may be walking way out in
the dry desert and here they are.
With not hardly a bush around,
a flock of **Lark Sparrows** will
appear, foraging on the ground.
Blink twice and they are gone.

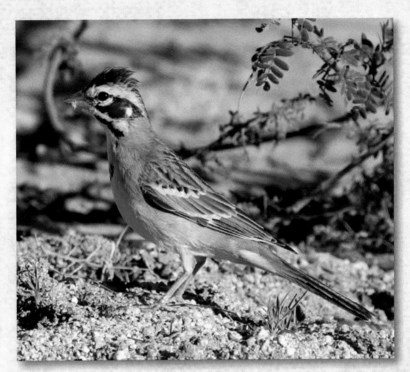

Lark Sparrow

Lark Sparrows walk rather
than hop like most sparrows while
searching on the ground for seeds
and insects. 6-7"

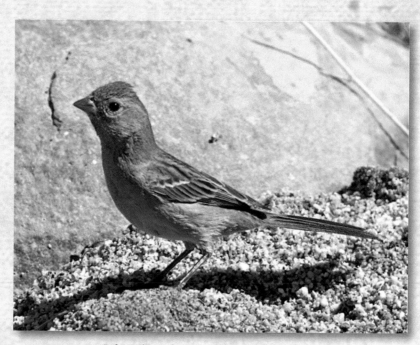

Black-chinned Sparrow

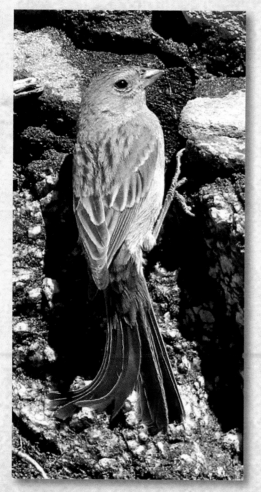

Very little is known about **Black-chinned Sparrows**. Secretive birds that have suffered from habitat loss due to overgrazing and the use of off-road vehicles. 5"

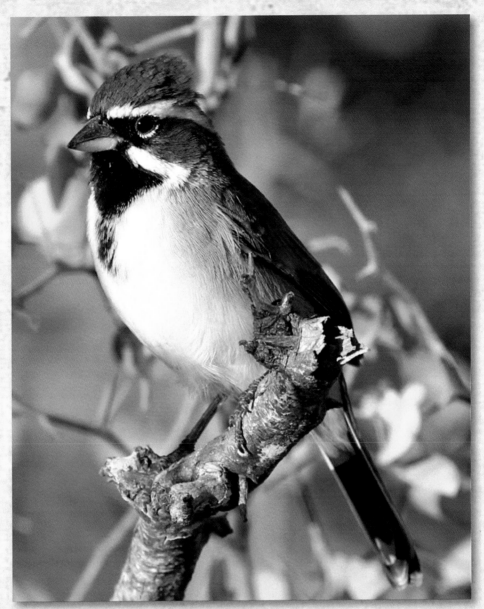

Black Throated Sparrow

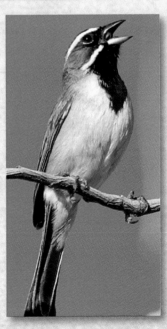

These birds survive long periods without water, obtaining moisture from the seeds and insects they eat. They have the sweetest, musical trill for a song that once you hear it you'll never forget. 5-6"

Estero San Jose del Cabo

Great Egret

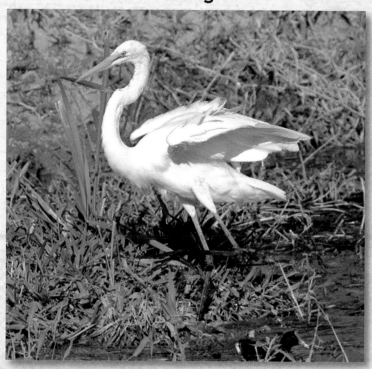

Estuaries like these in San Jose del Cabo used to be a place to dump trash. People didn't see their value. Estuaries are a place where much life begins. The eggs and larvae of fishes, crustaceans, insects, amphibians and more have a safe haven in which to develope. More and more people seem to realize the importance of habitats like these. Every time we visit the "esteros", we can see, little by little, they are being cleaned up by people that care enough to volunteer to do the work.

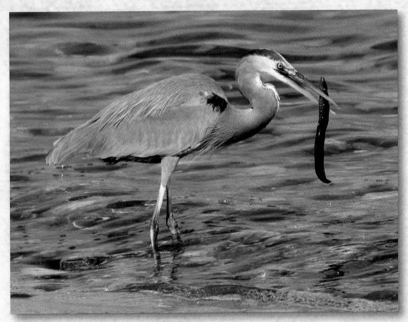

Great Blue Heron

This is a common and wide spread mostly gray heron that nest in colonies, usually in trees. Primarily fish eaters, **Great Blue Herons** also feed on snakes, rodents, small birds, frogs and other small animals. wing span 5-6′

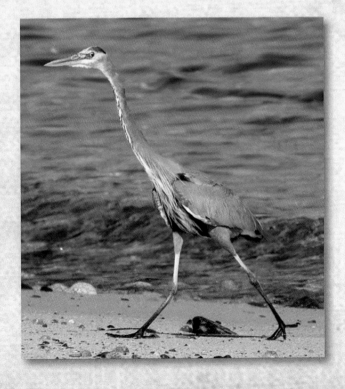

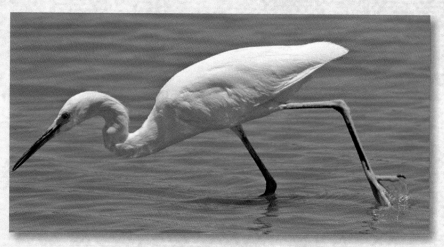

Snowy Egret

Snowy Egrets are graceful appearing herons distinguished by their dark bills and yellow feet. Wing span 3′

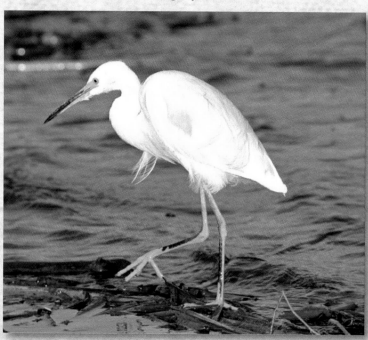

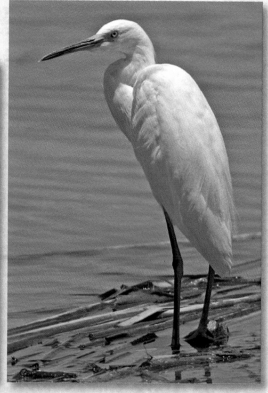

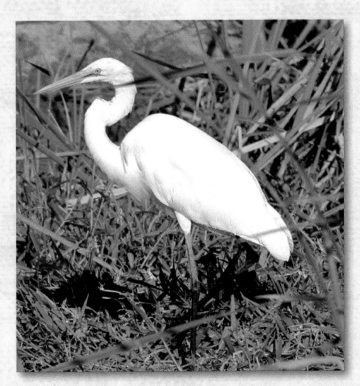

Great Egret

The diets of these birds consists of fish, frogs, snakes and insects. Hunted for their feathers to near extinction in the late 1800s, the Audubon Society successfully lobbied for a ban on the trade of the plumes of wild birds which helped save these beautiful herons. Wing span over 4'

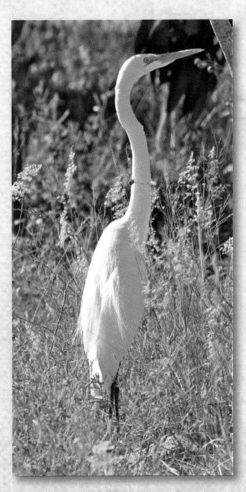

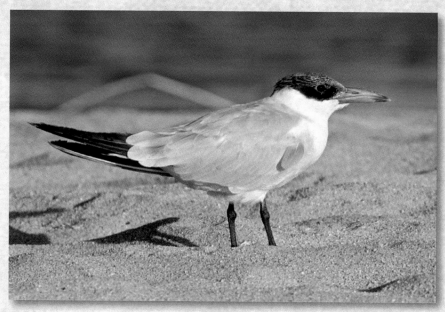

Caspian Tern

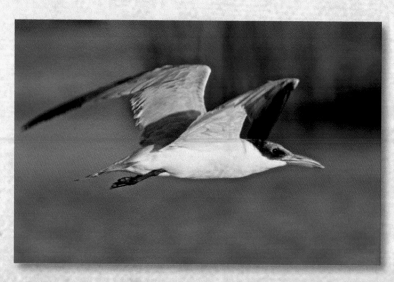

When we see these terns feeding just about anything is fair game. They aggressively prey on frogs, small birds, grasshoppers as well as small fish and crustaceans. 23"

juvenile

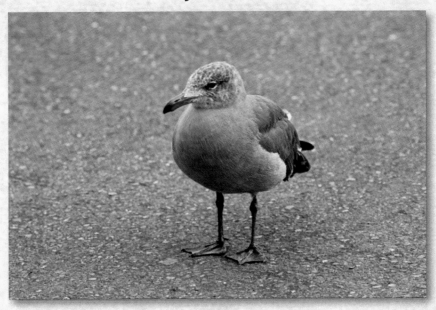

Heermann's Gull

These are beautiful gulls with red bills and gray heads that turn white as they mature. We see these gulls following fishing boats to steal food from brown pelicans. They will pester the pelicans until they cough up their catch. 20"

Yellow-footed Gull
These gulls may be endemic to the Gulf of California with a population smaller than any other North American gull. 27"

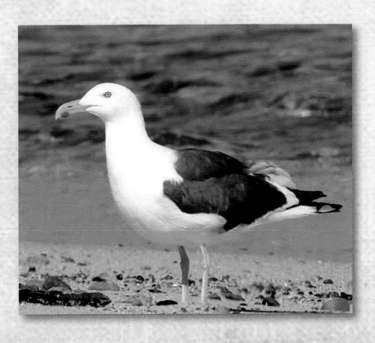

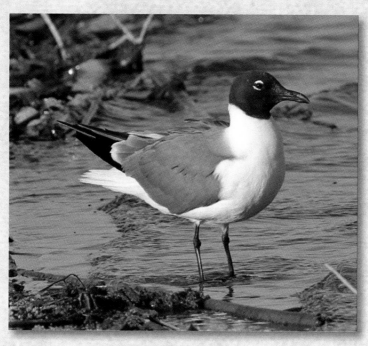

Laughing Gull

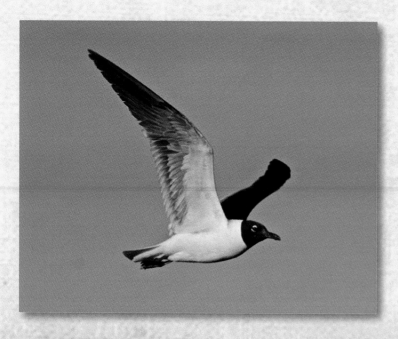

These gulls are easy to
spot amongst flocking gulls
because of their dark hoods.
Aptly named for their loud
call…Ha..Ha..Ha! 17"

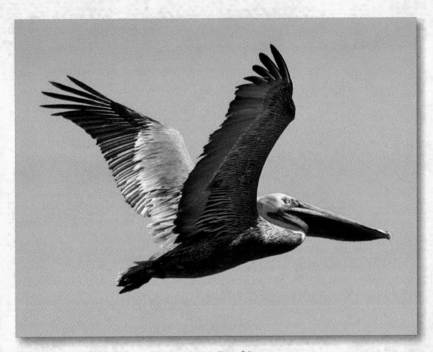

Brown Pelican

Brown Pelicans are
capable of holding up
to 3 gallons of water
(and fish) in their pouch.
Wing span 7 ft.

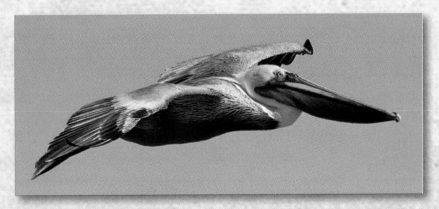

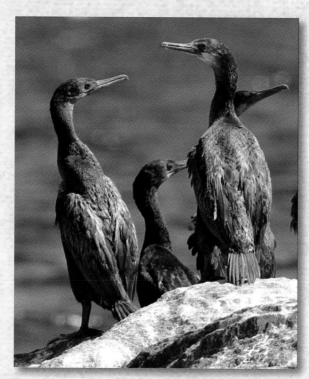

Brandt's Cormorants

We often see **Brandt's Cormorants** flying in long lines of hundreds of birds. Brandt's and other types of cormorants feed on large amounts small fish and crustaceans. 35"

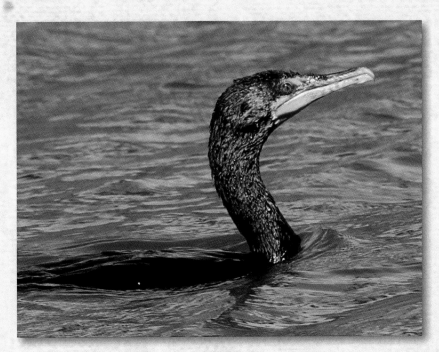

Double-crested Cormorant

These diving birds are very
common. Double-crested
Cormorants feed on small fish
and crustaceans. Up north,
these birds invade rivers and
bays to gobble up thousands of
salmon smolts. wing span 52"

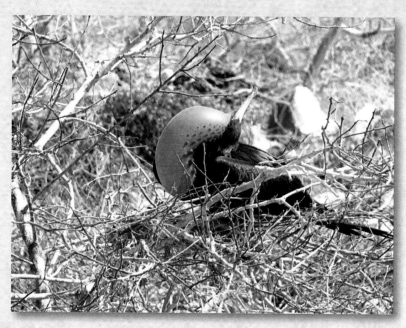

Magnificent Frigatebird

Male birds inflate their red-orange
throat patch like a balloon during
courtship display.

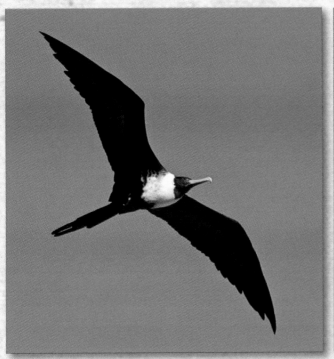 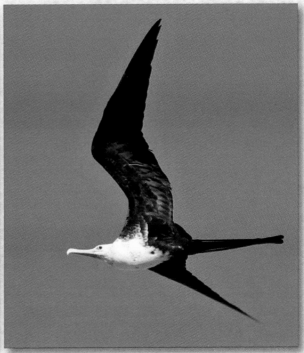

Clockwise, female, juvenile and male
Magnificent Frigatebirds.
Wing span 7-8′

Although exclusively
marine, **Magnificent
Frigatebirds** cannot
take off from the surface
of the water and must
return to land (or perhaps
a passing frigate) to
perch or rest.

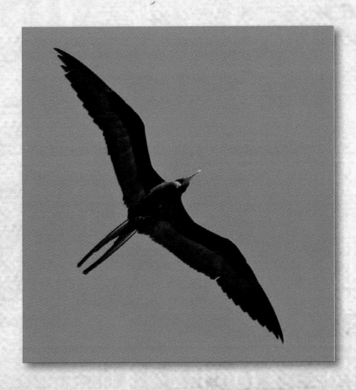

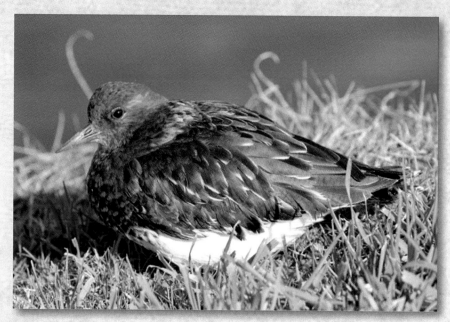

Black Turnstone

A small to medium sized sandpiper.
Black Turnstones prefer rocky areas
along the beaches where they turn over
stones and other debris while searching
for prey, especially crustaceans. 9"

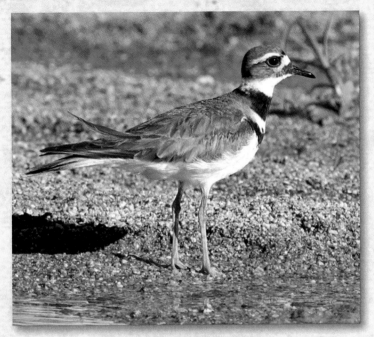

Killdeer

Distinctive double breast bands
visually separate these plovers from
other shorebirds. When danger, such
as a fox approaches a Killdeer's
nest, mom or dad will fain a broken
wing and move away from the nest
to distract the intruder. 11".

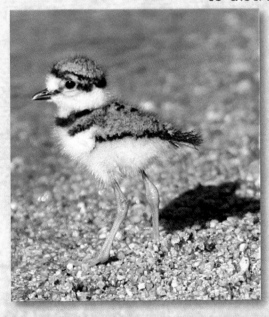

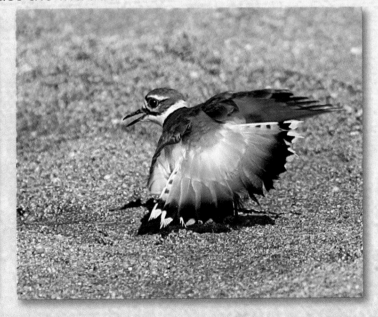

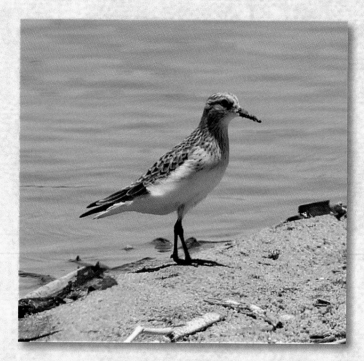

Baird's Sandpiper

We can distinguish these
sandpipers from the similar looking
Least Sandpiper by their larger
size. Also, these birds prefer fresh
water estuaries where they spend
the winters. 7-8"

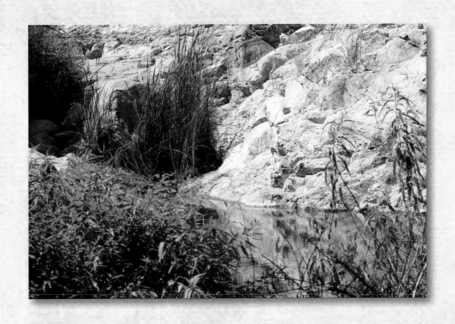

A desert oasis like this provides habitat for birds
such as...

the **Spotted Sandpiper.**

Distinguished by their
constant dipping motion.
They are sometimes called
"teeter-tails". 7-8"

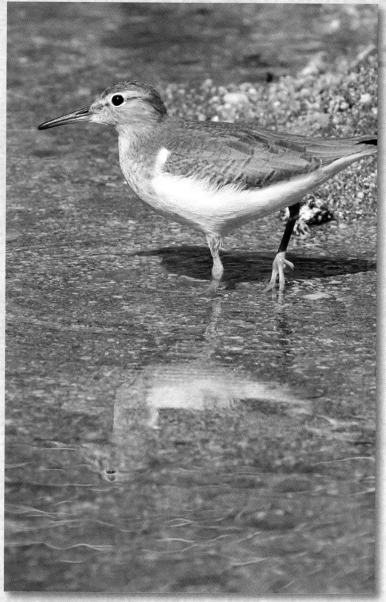

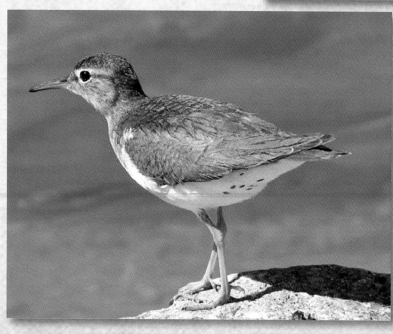

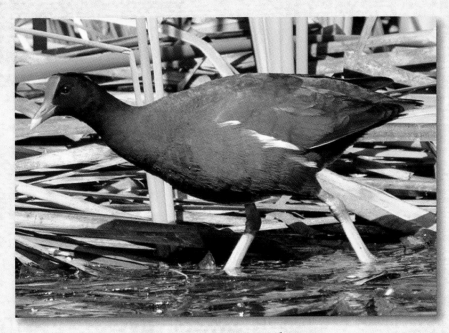

Common Moorhen

These duck-like birds are a common
site and sound in the fresh water
estuaries here in Baja. Their squawks
and croaks give the marshes an added
sense of life. These birds feed on
insects and seeds. 13"

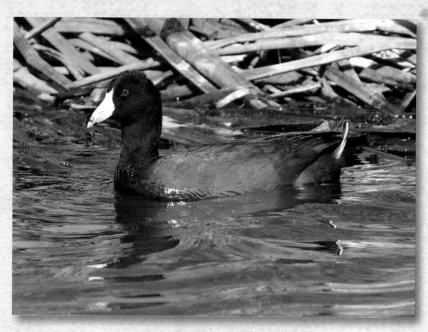

American Coot

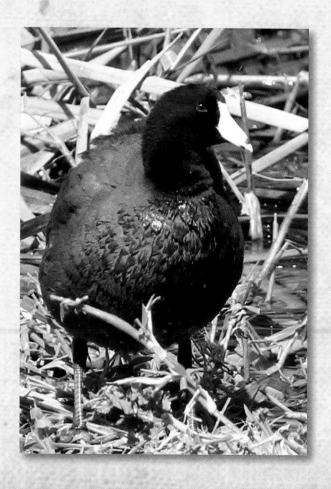

These duck-like birds are excellent divers. The absence of webbed feet doesn't impede their agility in the water. We see these birds steal food from other water birds. They also act as dabblers, grazing on the water surface for plants and insects. 15"

male

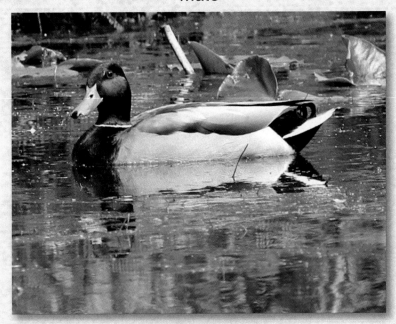

Mallard Duck

The female **Mallard Duck** is the one that does most of the quacking we associate with ducks.

Wherever there is fresh water, a marsh, estuary or pond, we may see **Mallard Ducks.** They will breed with domestic ducks creating some of those "funny looking" ducks we see. 24-27"

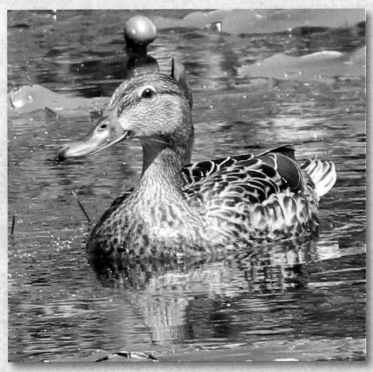

male

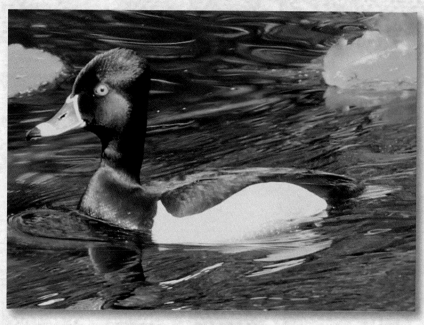

Ring-necked Duck

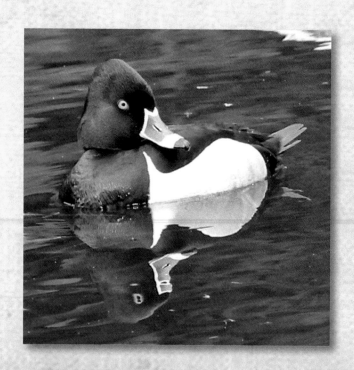

These ducks have long migrations and are vegetarians. Ringed-necked Ducks are shy and very hard to approach. 16"

female

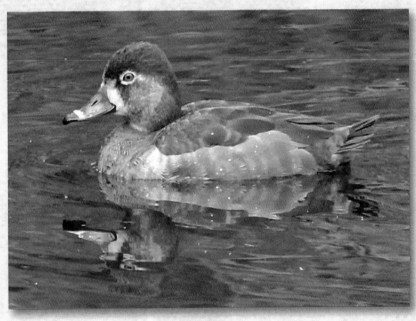

Ring-necked Duck

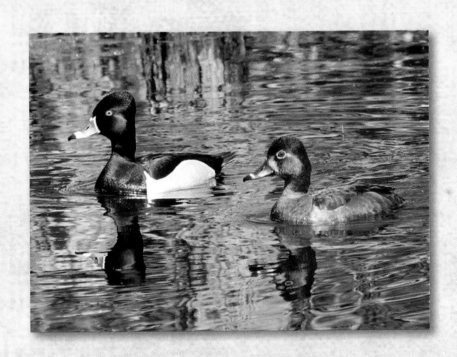

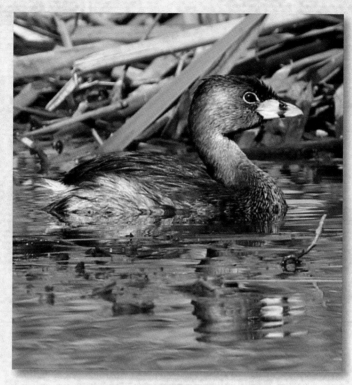

Pied-billed Grebe

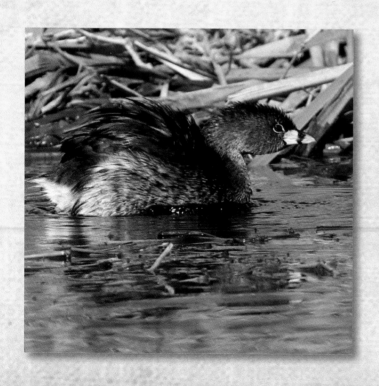

Pied-billed grebes are good divers but do not have webbed feet like a duck. They prefer to dive to escape enemies rather than fly away. We see them swimming with just their heads poked above the water watching for danger. 13"

male

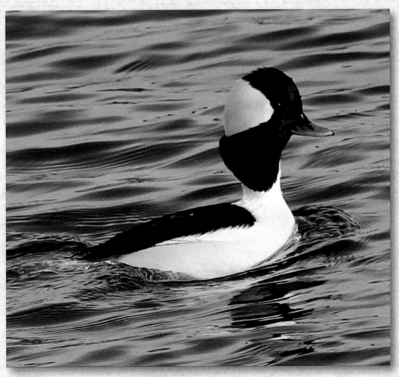

Buffelhead

female

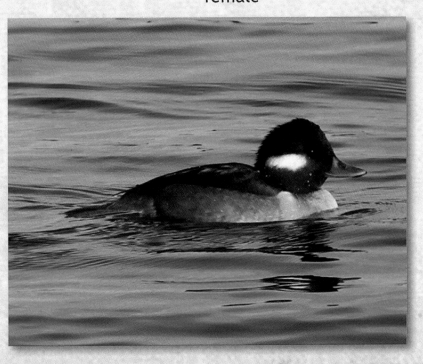

These fast-flying diving ducks visits our coastal bays and estuaries in small flocks. When diving for food, one bird usually stays on the surface watching for danger. 14"

male

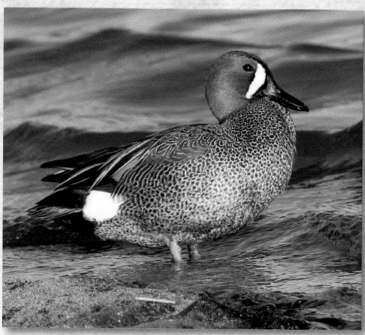

Blue-winged Teal

female

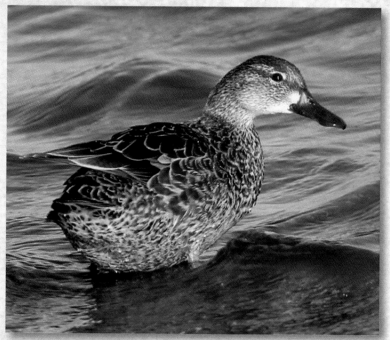

Like the **Cinnamon Teal, Blue-winged Teals** breed in the northern portions of North America. They spend the winters in shallow fresh water estuaries like the San Jose del Cabo Estero. 16"

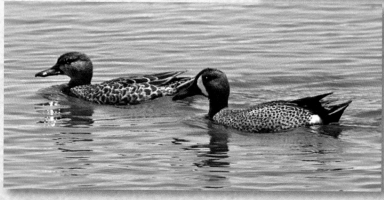

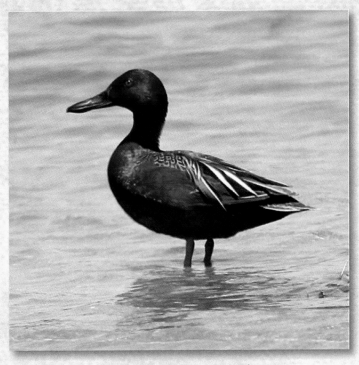

Cinnamon Teal

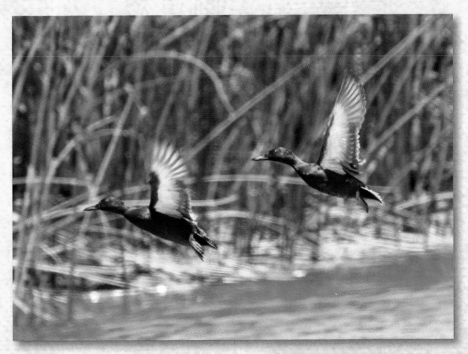

Cinnamon Teals are striking dabbling ducks. Some of them spend the winter in Baja. Their preferred habitat is mainly marshes and fresh water estuaries. 16"

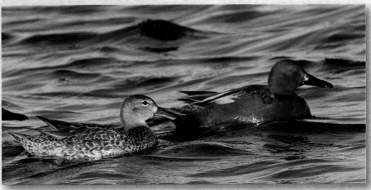

Turkey Vultures(right) search from the sky in groups or "committees". They spread out soaring over long distances watching each other for signs that food, usually carrion, has been found. Wing span 6´

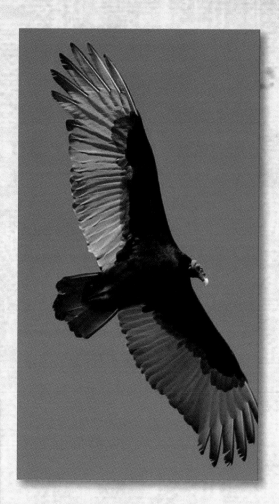

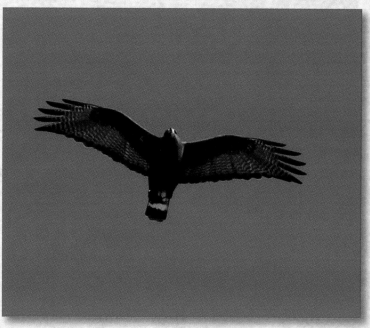

Zone-tailed Hawks may easily be mistaken for **Turkey Vultures** while in flight. They imitate the vultures to fool prey like small birds, reptiles and rodents that vultures don't hunt so the animals think they are safe. Note the white bars they have on their tails. Wing span 51".

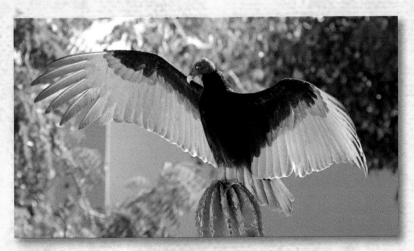

Turkey Vulture

One of the few birds that use their
sense of smell to find food.

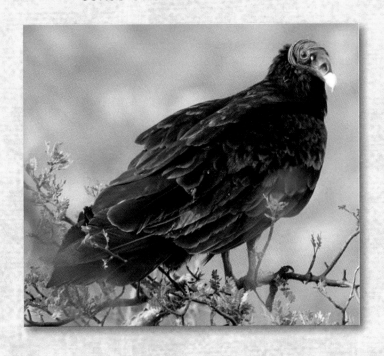

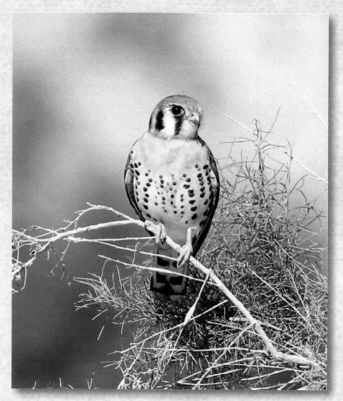

American Kestrel

Also known as **"Sparrow Hawks"**.
At the end of summer, families of
American Kestrels will have
parties. We see them calling and
chasing each other signaling the end
of nesting season. These are small
jay-sized falcons. 12"

female

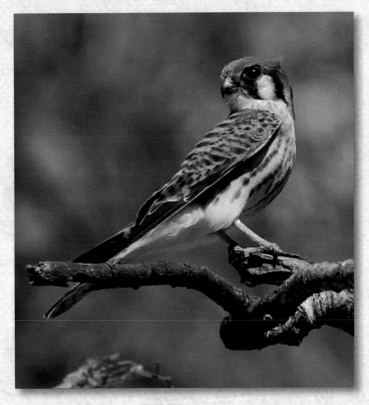

Unlike most falcons,
American Kestrels capture
most of their prey on the
ground. They feed on insects,
reptiles, rodents and small
birds.

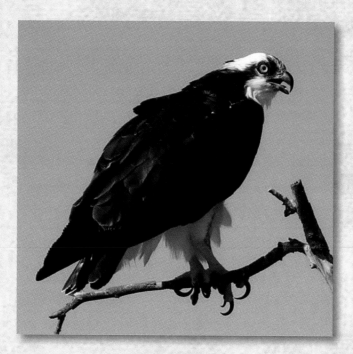

Osprey

These fish hawks have a wing span of more than 4 feet. Restrictions on pesticide use halted the decline of this species.

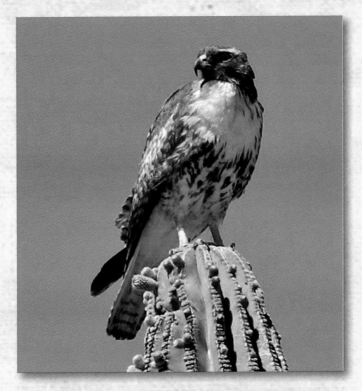

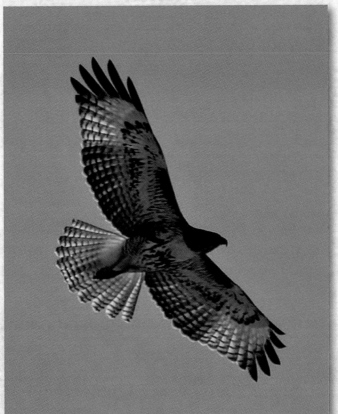

Red Tailed Hawks are often seen soaring in the sky searching for small prey such as rodents and reptiles. Our most common hawk also enjoyed rebounds in population after the banning of certain pesticides such as DDT which was ingested from the animals they consumed. Wing span 4′

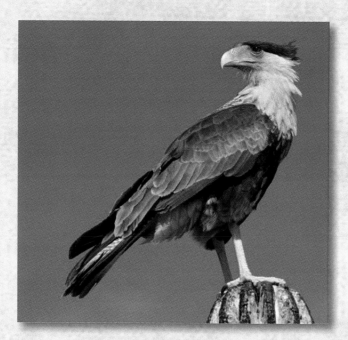

Crested Caracara

These national birds of Mexico have a 4 foot wing span and long legs that enable them to walk and run with ease. We often see them competing with Turkey vultures for carrion.

A Word For The Birds

September 1, 2006 was a day we will never forget. Hurricane John made landfall on Baja's East Cape region. Our little town, Los Barriles, was especially hard hit. Winds over 135 miles per hour were reported by many. Little twisters (as evidenced by the way our trees were twisted out of the ground) were spawned, causing much damage. The town was such a mess at the time that few noticed the birds were gone. Most of them had been killed by the winds and flying debris. For the following 3 years, insects were everywhere in Los Barriles. Mosquitoes, carrying Dengue fever, caused sickness in many. Ants, flies, bo bos, no see ums and every other kind of insect you can name, wreaked havoc on the people, our gardens and bugged us day and night. After 4 years the bird population grew back to the numbers enjoyed before John. By 2010 the birds had the insect population back under control. Birds don't just sing and fly around looking pretty for us, they help keep us healthy and enhance the quality of our lives in many ways.

About The Author

C.E. Llewellyn is a life-long wildlife enthusiast who has always spent as much time as possible in the outdoors. He hunted with a gun or a bow all his life. "If it moved and was fair game, no animal was safe around me". After his wife was diagnosed with a life threatening cancer, feelings about life changed for him. He started hunting only with a camera.

Chris and his wife Debbie, traveled the world searching for wildlife to photograph and study. "I like to share, especially through photography, the birds we see at home and in our travels. I'd like to think that I've helped at least some people better understand the beauty in nature that is all around us".

C.E.Llewellyn

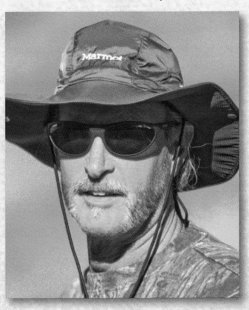

www.BirdsWeSee.com

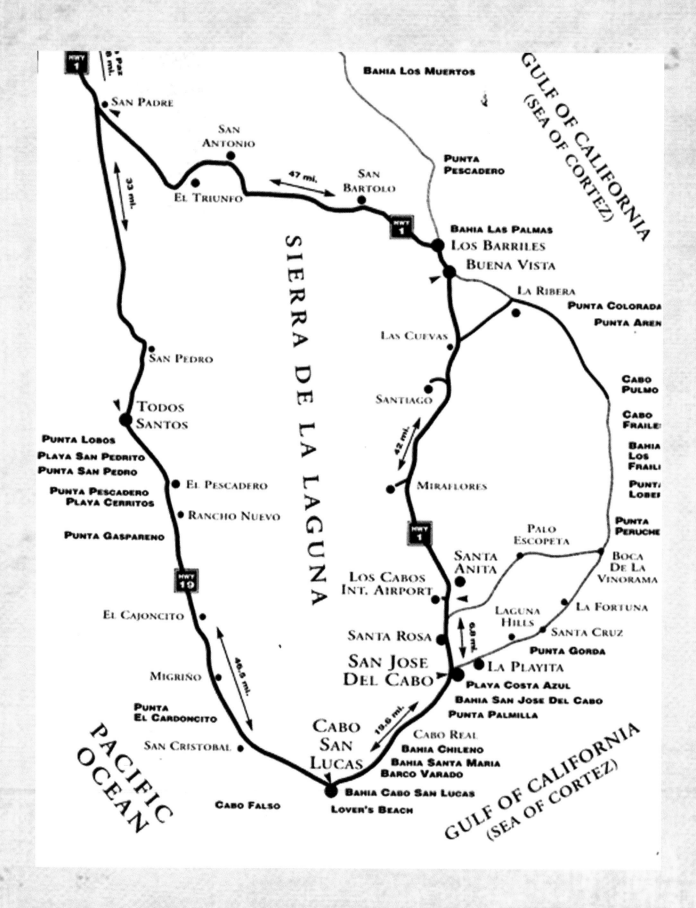

Edwards Brothers, Inc.
Thorofare, NJ USA
September 14, 2011